TSÉYI'

Deep in the Rock

TSÉYI'

Deep in the Rock

REFLECTIONS ON CANYON DE CHELLY

Text by

LAURA TOHE

Photographs by

STEPHEN E. STROM

THE UNIVERSITY OF ARIZONA PRESS

Tucson

The University of Arizona Press
Text © 2005 by Laura Tohe
Photographs © 2005 by Stephen E. Strom
This book is printed on acid-free, archival-quality paper.

Library of Congress Cataloging-in-Publication Data

Tohe, Laura.
 Tséyi'/deep in the rock : reflections on Canyon de Chelly / text by Laura Tohe ; photographs by
Stephen E. Strom.
 p. cm. — (Sun tracks ; v. 54)
 ISBN-13: 978-0-8165-2371-9 (pbk. : alk. paper)
 ISBN-10: 0-8165-2371-1 (pbk. : alk. paper)
 1. Canyon de Chelly National Monument (Ariz.)—Poetry. 2. Chelly, Canyon de (Ariz.)—Poetry.
I. Title: Deep in the rock. II. Strom, Stephen. III. Title. IV. Series.
PS501.S85
[PS3570.O423]
811'.6—dc22 2005005310

To my family and ancestors, whose hearts and

spirits are The People. To the many beautiful horses

in and around Tséyi', including those who came

from across the big water to be part of the beauty

in Diné bikéyah.

Contents

Illustrations

Acknowledgments

These poems have appeared or will appear in the following:

"Refugees in Our Own Land," *Ploughshares* (2004).

"Blue Horses Running," in *The Colour of Resistance: A Contemporary Collection of Writing by Aboriginal Women,* ed. Connie Fife (Toronto: Sister Vision Press, 1993), 100; and in *Returning the Gift,* ed. Joseph Bruchac (Tucson: University of Arizona Press, 1994), 288.

"Female Rain" and "Male Rain," in *Songs From this Earth on Turtle's Back: Contemporary American Indian Poetry,* ed. Joseph Bruchac (Greenfield Center, N.Y.: Greenfield Review Press, 1983), 255; and in *Making Friends with Water* (Omaha, Neb.: Nosila Press 1986); and as "Pluie Femelle" and "Pluie Male." *Estuaires Revue Culturelle* [Luxembourg] (1993):46.

"His Birth," in *The Clouds Threw this Light: Contemporary Native American Poetry,* ed. Phillip Foss (Santa Fe: Institute of American Indian Arts Press, 1983), 307; in *Five for Dance* (Omaha, Neb.: University of Nebraska Fine Arts Press); and in *All My Grandmothers Could Sing: Poems by Nebraska Women,* ed. J. Sornberger (Lincoln, Neb.: Free Rein Press, 1984), 38.

Thank you, Cassandra Manuelito-Kirkvliet, sister and friend, for your generosity in supporting me with "a room of my own" as these poems were coming into fruition. With much gratitude I also acknowledge those who shared their stories, presence, financial and editorial assistance, and the ubiquitous pickup truck: Erik, Shine, GG, Sim Chiang, OJ Vicenti, Arizona State University Women's Studies, Evangeline Parsons-Yazzie, Alice and Perry, the guides. Ahéhee' ntsaa t'áá 'ánółtso.

Introduction

Tséyi', or Canyon de Chelly as it is known on tourist maps, lies deep in the heart of the Diné homeland. In English it means "the place deep in the rock." I never visited the canyon as a child, even though I grew up on the other side of the mountain from it. In college my roommate and I drove to Junction Overlook and marveled at the view. I have a photo of her with the wind blowing in her face, sitting on the sandstone rocks. In another photo my grandmother is wearing a red blouse and standing near the rim of White House Overlook. That day is clear in my mind because we drove home over the dusty, washboardy rez roads through Sawmill. It was autumn, and the piñon trees were dropping their nuts. As we drove through the forest, my grandparents told the stories they knew of Tséyi'. My visits to the canyon were sporadic until I moved away from the Southwest.

It was during my visits to my parents' home in Mexican Springs that I first heard the canyon calling. "Hágo, hágo," *Come here, come here,* came a powerful voice, one that I couldn't ignore. Each time I went and took my children with me. We looked into the canyon, knowing that there was much more to what we were seeing. We knew that there were stories embedded in and around Tséyi'. I drove away with an ambivalent feeling that I had completed something, but only temporarily. I came to regard these visits as a kind of pilgrimage. I think the canyon knew that there would come a day when I would stay longer and write these poems.

These poems evolved from the canyon's voice—the stories in and around the rock walls, the sounds of animals and trees— and in the movements of light, wind, and water. From these movements one can begin to understand how the canyon expresses siihasin, the natural world forming harmony with thought, stability, and strength. In essence, beauty in all its sensual dimensions that touch us deeply. In the canyon, black crows soar on clouds of warm air currents. The wind rustles the cottonwood trees and monkey-egg trees, as we called the Russian olives when I was growing up. During an August visit, the clouds serendipitously covered the sky, creating a good day to shoot film. In October the brilliant yellows and reds of the cottonwoods emerged.

Tséyi' holds many stories of the Diné who inhabit it today and of the people who came before. It is said that the Swallow People lived here before the Diné arrived. Their extensive knowledge of agricultural practices enabled them to grow corn, squash, melons, and other foods that they taught the Diné to grow. These early people were named after the birds who build their homes in the rock walls. While the Swallow People's homes remain in the canyon, some of their petroglyphs are fading and are being replaced by more recent drawings. One such place is called "Newspaper Rock." Today these ancient people are called the Anasazi in the tourist brochures, but we remember them as the ancestors of the Pueblo people. Jeeps filled with tourists from all over the world arrive to tour the canyon and take photographs—rock stars, movie stars, and film companies included. At the restaurants in Chinle it's not unusual to hear four or more languages being spoken over coffee and fry bread.

The canyon gives much to all who live and visit. By the 1860s the Diné had firmly placed their roots in the bottomlands, planted their cornfields and peach orchards, and raised their flocks of sheep. The canyon had accepted The People. In turn, the Diné had found agreement with the canyon, where they could build their homes, raise their families, and live a harmonious life based on hózhǫ́. In this way The People chose to live a life filled with spiritual beauty based on the values and

teachings of the Holy People, sacred beings in the Diné world-view. To show their gratitude, The People still give offerings to the Holy People at sacred sites at the canyon.

It nearly came to an end when the U.S. cavalry arrived in the mid 1860s under the military leadership of Kit Carson, the man named Bi'éé'łeechii'í, Red Shirt. During this dark era of U.S. history, indigenous peoples were systematically being placed on Indian reservations throughout the country. Carson marched into the canyon with his soldiers, destroyed the food supplies, and a bloody battle ensued. Some of The People took refuge on Fortress Rock in hopes of outlasting the military. To save themselves, The People did what they had to, even if it meant taking drastic actions. Some kept hopes of returning, so they hid their precious pottery and jewelry in small caves. The People were forcibly marched away in 1864 to Hwéeldi, Fort Sumner, New Mexico, where they were imprisoned and endured great hardship for four years. This story has a happy ending, though. The People signed a treaty with the U.S. government in 1868 that allowed them to return to the Diné homeland. They must have cried tears of joy when they came in view of one of the sacred mountains that would guide their return to the homeland we call Diné bikéyah. The spirit of the Diné remains resilient. This is the legacy that has been passed on by my ancestors, and so it is with great love and passion that I wrote these poems about Tséyi', who knew I was to return to write this collection.

The bilingual poems and words express the worldview and our relationship to the earth. Our name, The People, distinguishes us from other inhabitants who live in the great circle of life. To use the gift of my language is to speak and write it with ethical thought and consideration.

To write about Tséyi' is to include the past, the present, and The People's language and worldview. Dualities such as female and male, sky and earth, love and war, light and dark-ness are all around us. If we are to survive, we must find a way to achieve balance and harmony in this world. Through Stephen Strom's images we are led to that harmony of color, light, and form that pronounce the earth as possessing siihasin, living, breathing, thinking. These intersections create subtle meditations of the earth, and other times they appear as sensual as the motion of wind swirling on a bed of sand.

While the photographs are not the kinds of images accessible in most books of southwestern landscapes, Strom's images invite us to look at the earth in new ways. His artistic eye for the subtleties and mysticism of the earth create powerful images that resonate. We discovered that as we moved through the process of creating this book, our work revealed the evocation of the beauty and spirit of place and people, the power of stories and images, and in this way we hope these works touch the universal spirit.

While my relationship to the world is rooted in the worldview of my family and ancestors, I can move comfortably from Diné bikéyah to the Eiffel Tower, from the Negro River in Brazil to the black beaches on Santorini Island in Greece. From these travels and the people I meet, I gain the nourishment and inspiration I need to sustain and feed my creative expressions. In this way I am part of the world, and I am part of the value of inclusivity that my family and ancestors value.

Each time I return to Tséyi' it's as if I had never laid eyes on it. Standing at the rim opens all the possibilities of wonderment, awe, inspiration, and, above all, mystery. I know now it was the canyon who chose me to write these poems.

TSÉYI'

Deep in the Rock

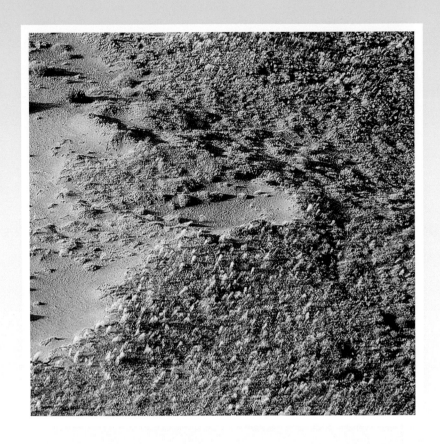

Sand and brush from Tséyi' Overlook

On the Round Belly of the Earth

From the sky the earth is a pattern of squares and rectangles upon the humid green of the Midwest. The Germans, Swedes, Danes, and Eastern Europeans that flooded this country brought with them the fury to own the land. First by the force of themselves, opening the earth and dropping seeds into her, they realized the abundance of the land and wanted more. The plane turns southward and toward home, where my mother buried my umbilical cord so that my spirit would remain tied to Nahasdzáán, the earth.

Getting into the mountain states, the shapes turn into green circles that spin. I wonder at the perfect roundness of them because from the ground, the shapes aren't evident. Like the geometric shapes of the Midwest, the circles mean the land has been worked for what it can give.

In the Southwest the terrain changes again. Now light-colored fissures run like roots on the dry mesas extending outward near Sandia Mountain. Roads and highways wind around the canyons and dry riverbeds. The Rio Grande flows south, and on both sides pueblos and towns have sprung up along side it.

The contrast here is how the land yields only to itself, defying the manipulations of Western man and his machines. The indigenous peoples came to this knowledge thousands of years ago. They took only what the earth would give them. In doing so, they showed their gratitude by offering prayers so that the earth would continue to sustain their spirits and fragile lives. They made their homes and ceremonial centers in a circle on the round belly of the earth.

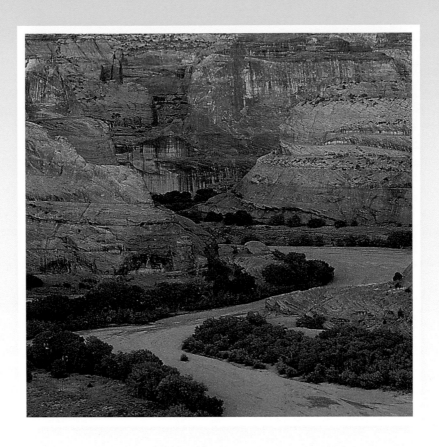

Canyon walls from Junction Overlook at sunset

What Made this Earth Red?

What made this earth red? These rocks red? Was it the light from earth and sky to remind us at day's end of the color of our births? Is it all the trails we took upon ourselves or that were forced upon us, beginning with our blood trails to Hwéeldi and back? Our fragile lives, tentative, brave, wavering through all the worlds we've traveled. And each time we arrived, the quickening of our hearts.

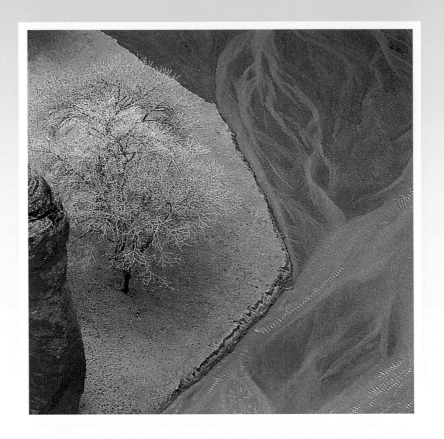

Tree and rock spire, overlook from canyon rim

At the Rim

Enrico says, "When I stand here, I want to jump into the canyon. When I visit the ocean, I want to run into it. It's a psychological desire to want to become one with what's more powerful than us." Someone told him that once. Looking into the canyon, I know what he means. Look. This urge to put feet to the rocky edge, bend knees and extend arms like an Olympian diver. Take a breath and summon all your courage. Pushing off into airiness isn't hard if you know there's love waiting in the warm sand below to dust the fright off your shoulders and ask how your trip was. Love places a warm hand on your belly and pulls the covers over your cold shoulders, sings a mountain song into the canal of your ear. Love offers shelter from blades and gunshots, opens the folds of its being, and builds a fire to wait for your return. At the rim, I want to jump into your canyon and run into your ocean, naked and reborn.

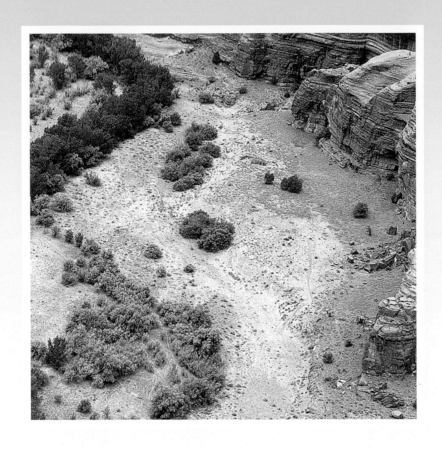

Canyon floor from Spider Rock Overlook (summer)

Many Horses

The day you arrived on your Turquoise Horse I was already riding my Rainbow
Horse, as we were promised beautiful horses to carry us into this world. On this
rain-blessed earth you will pause at Ch'ooshgai to sing:

> Dził bich'į' yisháał . . . I am approaching the mountain
> Dził bikáá' haashá . . . I am ascending the mountain
> Dził bikáá' naashá . . . I am walking on the mountain
> Dził bąąhdóó 'adaasháah . . . I am descending the mountain
> Dził bits'ąąjį' dah diisháah . . . I am leaving the mountain

I wait for you at the mouth of Deep Within the Rock. You arrive wearing the scent
of sage, and this mountain song pouring from the cup of your heart, the way the
Diné spiraled into this world protected with a song. I recognize you by your sweet
song and your horse. We urge our horses on. Tracks imbedded in the sand.

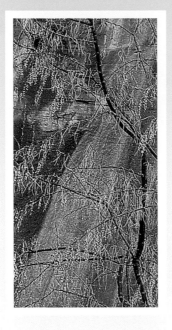
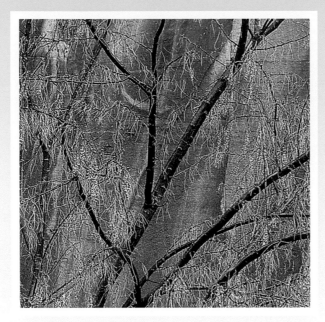
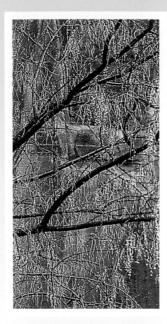

Canyon walls through trees, White House Ruin

Deep in the Rock

I.

Deep in the rock, the tamarisk and monkey-egg trees have dug in to prevent erosion. Like the Diné, they refuse to leave. These newcomers prefer a symphony of crows playing against a solid backdrop. They spread themselves, thick as thieves, drinking away the water for the sheep. Someone lights a match to them. Too late, their roots have memorized the canyon's endoderm. When the flood came, their arms groped for the sky as they sank into the muddy chocolate waters. A mass of tangled hair rose when the canyon emptied. Then a shivering silhouette of branches, like cracks in the sky.

II.

Deep in the rock, the interplay of texture and color. Iron and manganese dribble down the rock face. Will it matter to this land, carved by steady wind and rain, after our bones have crumbled into dust?

III.

Deep in the rock, crows make echoes, gáagii, gáagii. Their name is pure onomatopoeia. Gáagii are everywhere, picking up the remains of what humans leave, even the stuff that isn't intended for them, like the boxer shorts stolen from the clothesline. My cousins laughed so hard when they fluttered away beneath the gáagii's grasp. Gáagii are everywhere and are taken for granted. If they were to leave, they would be missed.

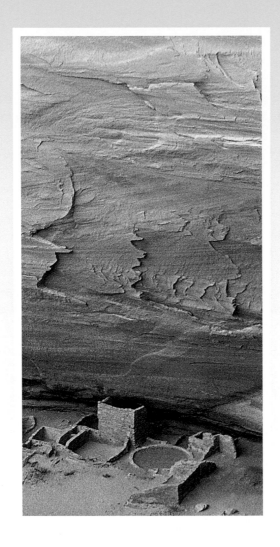

Mummy Cave Ruin from canyon rim

Jiní

Jiní, *they say.* We accept jiní as part of our stories on simple faith. It's not important who said it, but that it was said. The stories become part of our collective memory. Our stories begin and end with jiní. At Ya'dziilzihii is the place named after the contest where young men shot flocks of arrows toward the clouds to see who could shoot the farthest, jiní. At Séí Delehí, lover's trysts took place on the wide sandy bed near the tamarisks. Jiní.

"It's best to take time to listen to the stories and not be in a hurry," the Diné elder says. He lives near White House Ruins, where you can buy a cappuccino and tourist jewelry. He knows the stories not echoed on paper. "Díí' kwe'é Dibé Yázhí Bich'ah wolyé jiní." *This place is called Little Lamb's Cap, they say.* "A man stayed behind and drew the animals on the canyon wall and blessed it with prayers for The People's return. He waited. Time passed. Then a long-robed man came through the canyon. He's there on the wall with the others."

Which will last longer, the drawings or the stories of jiní?

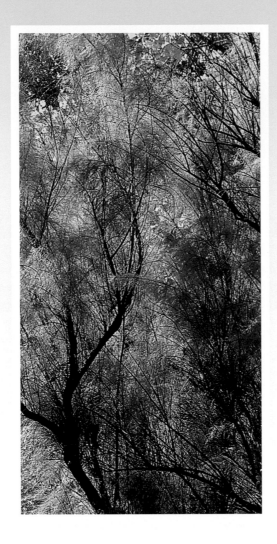

Trees in fall from tunnel overlook

A Tree Grows near the Road

A tree grows near the road.
 The branches curve above the tracks of
 trucks and jeeps used to run tourists
 in and out of the canyon—half-day, all-day tours, cameras click,
coconut sunscreen
 with SPF 30 scents the air.

Someone shudders in that tree that reaches across the dirt trail. It is a woman
driven from her home. Her husband and children scorched, along with the corn
and the peach orchards. The sheep slaughtered. Below, the horse soldier paces
back and forth, back and forth. She sees horse prints in the sand burying hers.

 Brown Diné women sell sodas and turquoise jewelry
 near the grove of cottonwoods at Antelope House.
 Tourists must love the authenticity of "Real Indians."

This canyon, elegant, sexy, ancient, and all at once dangerous, demands the price
of memory and the stories of jiní. So remember, this place where the tree arches
over the road represents the flow of the water and the woman who got away. It is
the road that runs through us like ancestor blood.

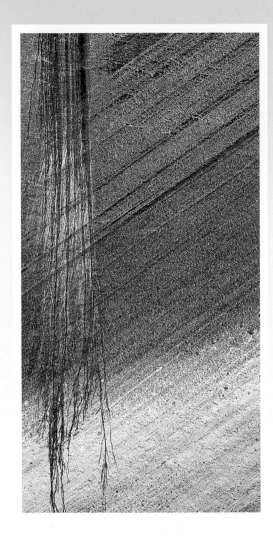

Water-streaked canyon wall near the canyon mouth

On the Other Side

On the other side is a wall
where the souls of the dead
watch the tears of the living flow.

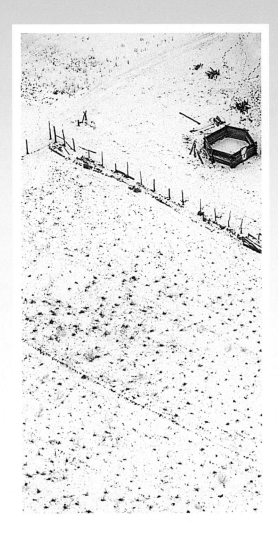

Abandoned Hogan from canyon rim

Refugees in Our Own Land

The night is busy with the growth of stars. Above us peaceful. Shiyáázh, *my son,* fusses in his cradleboard. The protective rainbow, shaped by his father, arches over his face. In the dark sand below, Monster Slayer's archenemy rises again to pull us off this rock where we've taken refuge since winter's approach.

The wind stops. Clouds drift across the moon. We pull water silently from below, near the soldier's feet. Silence is our cover. I pull my son close and place my hand on my baby's cheek to quiet him. "Shhh, shee'awéé', shiyázhí, shhh." *Hush, baby, my beloved, hush.* With my finger I circle the pulse just above his ear. He makes tiny lapping sounds with his mouth and turns toward my breast for the comfort of my milk. But my breast is a sieve from which the enemy drinks. I am dry.

These hands mixed bread dough for the evening meal, planted corn, and gathered pollen from the tender shoots. These hands held my husband's kisses and caressed my baby's soft bones as he grew inside me. We sailed the river that led us to the ocean of all beginnings. The night cries like an owl. My beloved son's eyes are full of stars. A drowning breath in his throat. Take this map of rainbows and fly, fly, child.

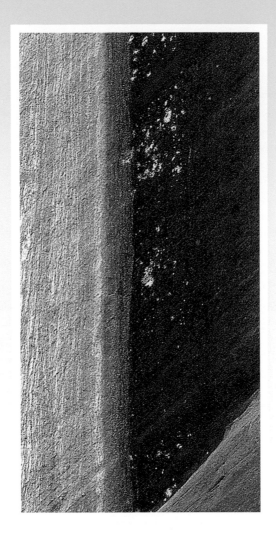

Canyon wall near the canyon mouth

Canyon del Muerto

It was September when we stood at the rim and peered into the darkness. The canyon trembled with stories. "Can you hear it?" asked the policeman. Panic rises like smoke. Rock walls shake loose the stomp of horses pulling wagons, the fury of soldiers shouting, "Dirty vermin! You're in the way!" Bullets whiz past the man holding his abbreviated life seeping into the sandy bed. His wife's hair, unraveled and loose, flows down her back like a fire licking its own tail. The People in a stampede for cover. The blood memory congeals in us. Then the moaning silence. Genocide. A recent tale recorded in the cracked walls. Above us the stars, a pattern punched into the black sky that airline jets float beneath.

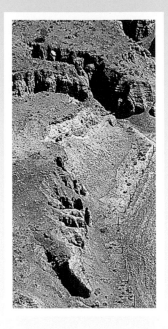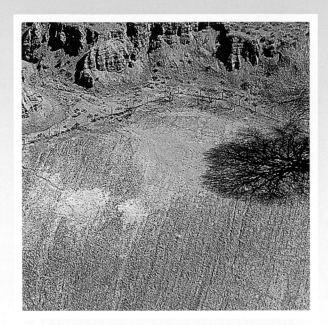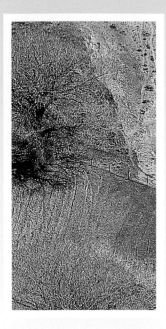

Tilled field from canyon rim

Returning

I've been somewhere. My mind struggles to remember the cornfields and fruit trees blooming like a young woman's body and the place where my brothers built the shade house for our sister's marriage beneath the slender moon, where my mother wove her last blanket.

I've walked this empty road before in the month of the big harvest, when The People left the canyon with wagons loaded with peaches and corn to take to relatives and to trade with our neighbors who live on the high, windy mesas.

I am returning to the red rocks that once cradled us and from whose arms we were torn when death marched in, surrounded us, and slaughtered everything that we loved.

I am the kidnapped one and survived to escape the enemy, who feared our graceful lives, because we know that *Beauty* cannot be captured with words or jails.

I hold nothing in my hands except the lines that tell my fate. I long for the comfort of my mother's stories, cooking, anything. How she roasted mutton ribs, crispy and salty. Her stories of my Amazon grandmothers, who claimed and discarded husbands like ashes.

Dust clouds billow beneath my bare feet. The ground feels familiar, and I walk easily on the sand that flows from the mouth of the canyon. A crow glides a new pattern in the wake of grief's echoes.

Thick black ants watch Earth-Surface child return. "Ahhh," they say, "leave this one alone; she is returning from that place."

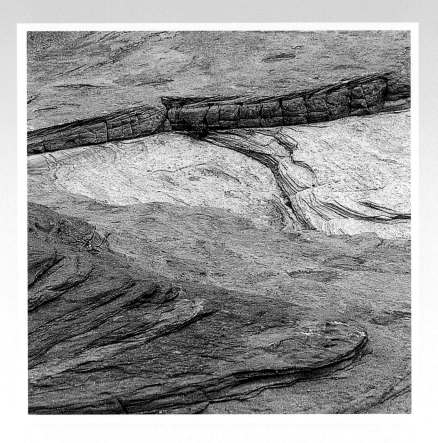

Rock ledges, Mummy Cave Overlook

Echoes

Anyone who's been around this area long enough will hear echoes of stories old and recent. Once I fell from a ladder and fortunately didn't break any bones, but for weeks I was left with bruised ribs and a deep purple bruise in the shape of a stingray. I met a Diné woman in Oregon and told her about my fall. She consoled me with a story about her son, who fell from the rim at the canyon. He had partied with friends the night the rain greased the rocks slippery. When he stood, the canyon grabbed him. Miraculously, he landed on a ledge, because he remembered to call out his warrior name. Rescue took several hours, and he was not healed until the ancestral Mountain Spirits descended the mountain through a dream and brought him the courage to remove his cast.

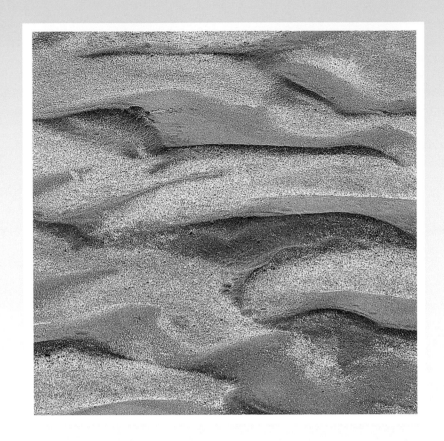

Patterns, drying river mud I: canyon floor

What Came

The remains of summer's heat settle into the rock cliffs and sand that has swallowed whole pickup trucks beneath its cover. Later, a female rain comes to cool the earth and leaves a damp trail. A doe stands by the road under the abalone moon.

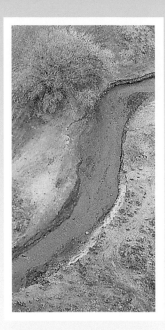
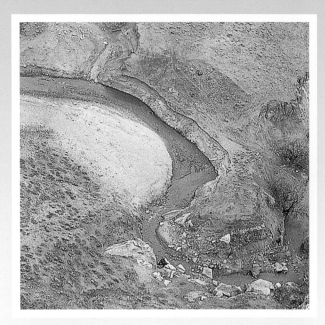
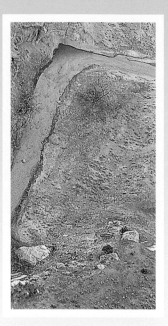

Niłtsą́ Bi'áád

Niłtsą́ bi'áád
 Shá'di'ááhdę́ę'go dah naaldogo 'alzhish
 k'ós hazlį́į'
 honeezk'ází
 niłtsą́ bi'áád bitázhool bijooltsą́
 áádóó niłtsą́ bi'áád biyázhí bídii'na'

Naaniiniiłkaahgo
 niłtsą́ bi'áád biyázhí hazlį́į'
 ch'íl látah hózhóón dahtoo'bee 'ałch'į' háazhah
 áádóó nihik'inizdidlááad

Female Rain

Female Rain
 Dancing from the south
 cloudy cool and gray
 pregnant with rainchild

At dawn she gives birth to a gentle mist
flowers bow with wet sustenance
 luminescence all around

 Wash from canyon rim (winter)

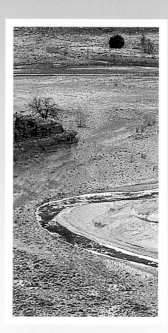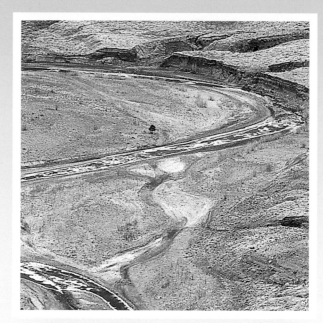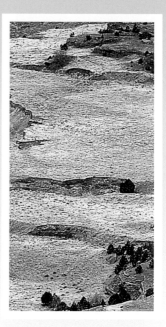

Niłtsą́ Biką'

Niłtsą́ biką'
Aadéę́' łį́į' diłhiłgo tł'éé' nahalingo bił ch'éldloozh
 báhách'į'go naayéé'ee k'ehgo ts'ida deesk'aazgo áhoolaa
 tó yílą̨d dóó níyol tsoh áhoolaa

Hashké niłtsą́ biką' naazbaa'
 tł'éé' bíighah atah názhnoodahgo yiská
 áádóó łį́į' bił anááldloozh
 anaa' yéę t'áá 'ákǫ́ǫ́go 'aliilaa

Male Rain

Male Rain
 He comes riding a dark horse
 angry malevolent cold

 bringing floods and heavy winds
Warrior rain having a 49 night
 then rides away leaving
 his enemy behind

Canyon floor from Spider Rock Overlook (winter)

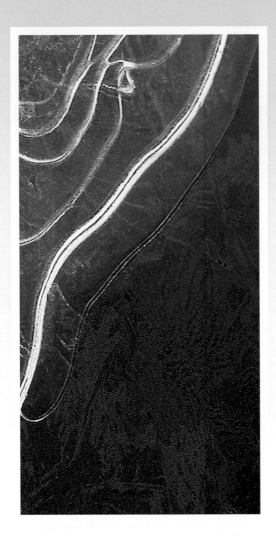

Ice on frozen stream I, near White House Ruin

Crossing

I've crossed over for love
 for the language that is ours
 for the grandmothers who know
 the wisdom of the earth
 for this snow-covered winter night
 in the middle of our glittering homeland
 for the horses that cover themselves beneath
 the downy snow
 for the ragged ones who've lost their way home
 and leave their sad trails on the weary sidewalks
 for the four mountains that protect us
 in whose laps we dream
 for your bravery that shields us
 against monsters of the 21st century
 for your stories that you reveal in the arms of night

May I be worthy
May I turn away from fear
 towards your lamp of love
I am unfurling this ribboned road
 that leads you to me

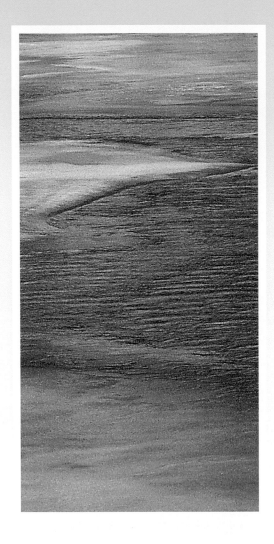

Ice on frozen stream II, near White House Ruin

Blue Clouds

I'd never seen blue clouds . . . ever.
I swear until the evening you whispered
that your name is Blue Cloud
and filled my ear with the trembling of female rain.

Winter mornings when the red earth is dry, I will reach for you.

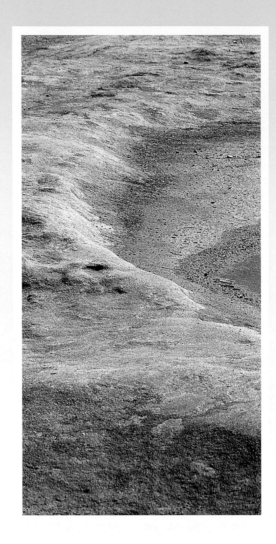

Water pocket from canyon rim near Junction Overlook I

Cello

Layer upon layer of quarter notes, half notes, open notes rises like mist at the beginning of time. My body is pressed between you and your cello. You play and play and play. . . . Much later, I'll press myself against the sandstone and sip from the bowls filled with rain. I'll turn to the canyon and not hear shotguns but your cello full of longing.

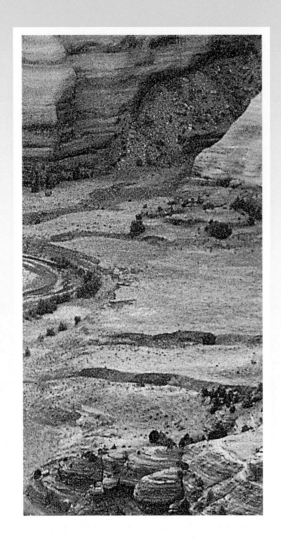

Canyon walls from Spider Rock Overlook

Dinétah

The silver breath of a thousand horses,
and it is only yours that I seek.

I happily step over into existence,
into our canyons,
our rivers,
our mountains,
our valleys.
Sky beauty above and
earth beauty below.

Oh, how I've missed you.
To think I was away for so long,
and you were always there,
waiting on the red earth
to hold yourself open
and offer to carry my burden.

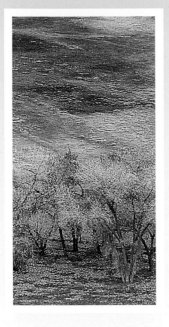
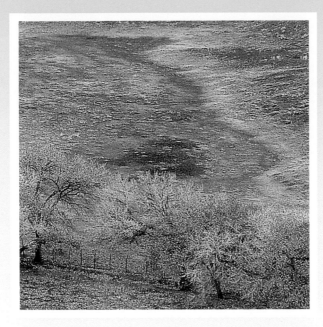
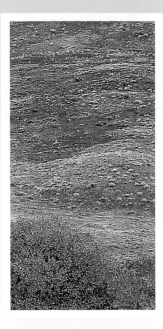

Farm and trees from canyon rim

I'm with You, You're with Me

On a bed of down and linen
stretched like ripe canvas

 Lay me down, sweet love

In this house with doors that don't lock
 a candle melts into darkness,
and I lay tucked into the warm shadow
 of your last night in America

We struggle to hold back the tick tock of night,
 the sun pushing us in degrees
 toward the sliver of dawn
 This broken cord of good-byes,
 this raw land
You, resting your arms on my car window
Me, remembering you that way
just before we surrendered the spent night

 Lay me down, sweet love

To lose myself in your eyes again,
 and I pretend that I heard your every word
Let us this last tango, this last blues song sustain
our dreams and hold the stars above our sleeping heads
and unite our faraway love in the hands of the ocean
I'm with you, you're with me

in this new morning,
gentle as your breath on my breast

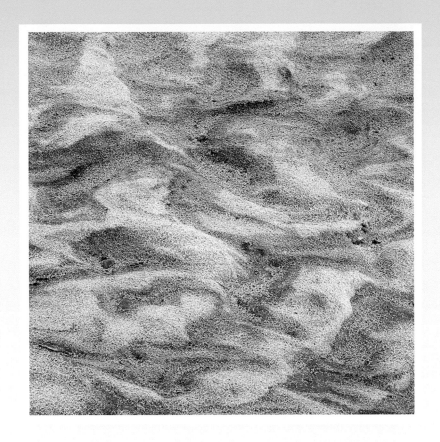

Patterns, drying river mud II: canyon floor

Poem about You

Just to be near you,
to watch you awaken in your bed at dawn,
to hear you say, "Nidlohísh?" *Are you cold?*
 Then you pull the red blanket over my shoulders.

Your heat feels like no other lover's noonday rendezvous.
Your beauty stuns even in the glare of this light.

When you call, I'm all afumble,
gathering the miles and hours between us. My hungry heart in chase of
 your kisses that settle in the cups of my elbows,
 your breath blowing through my hair.

 You ask nothing of me, yet I eagerly surrender my crusty obsessions with
 time and cities.

I can't go near you without feeling the earth sing through you.

At the edge of day,

 when I leave,

the wind is a painter shifting the sand dune of our bodies on its canvas.

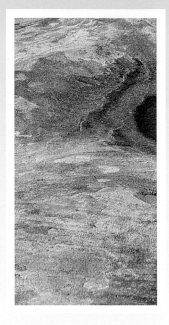
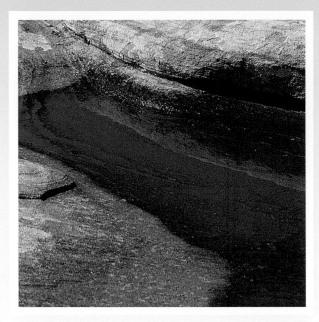
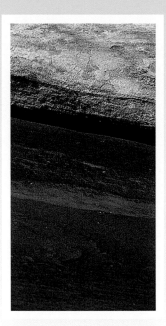

Water pocket from canyon rim near Junction Overlook II

Over Here

I know you live somewhere near the tall buildings in the city, or is it across the ocean? You told me, but I refuse to assign story to place. I prefer the rim of the canyon, where I am free to roam and not let the sparkling lights of the city catch me the way they do Coyote.

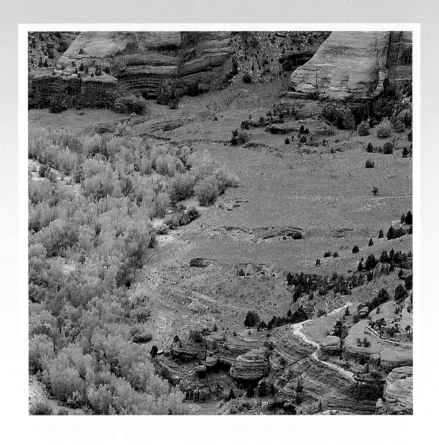

Canyon bottom from Spider Rock Overlook (fall)

Blue Horses Running

Possibilities exist with you,
 where sagebrush dots the desertscape,
 where a string of crows floats like beads on a
 turquoise sky, and where mountains hold plants spread
 out like a blanket

We travel the colors of brilliant red rock cliffs
 that form within ancestral space,
 we travel on the colors of the rainbow
 and know what it means to come forth, to awaken

Here it's possible to know that you belong to the earth
 in a language that names us,
 that this place formed you,
 and carved the high bones in your face

Cedar and rock monoliths know the motion of wind,
 the patience of waiting, the gathering of strength,
 here it's possible to know the world in the words of our ancestors,
 the simple beauty of blue horses running

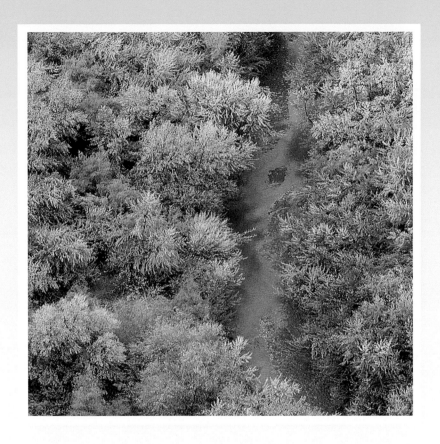

Trees and stream from Tséyi' Overlook

His Birth

In a dream I saw the basket of life
　　　　it opened and all around there was beauty
　　　　　　beauty above and below

At dawn he climbed into this world
　　　　wet and red
across the vastness into light

His heartbeat strong like a basket made of clouds
　　woven from the silence of the desert

About the Author

Laura Tohe is Diné and was born and raised on the Navajo reservation. She authored *No Parole Today*, which won the Poetry of the Year award in 1999, presented by the Wordcraft Circle of Native American Writers and Storytellers, and the chapbook *Making Friends with Water*. Laura also co-edited *Sister Nations: Native American Women Writers on Community*. She writes essays, stories, and children's plays that have appeared in Canada and Europe. Her contributions to American Indian literature have been recognized through the Reader's Digest Fund. Laura is Associate Professor in the Department of English at Arizona State University, where she teaches American Indian literature and writing.

About the Photographer

Stephen Strom is an astronomer at the National Optical Astronomy Observatory. He received bachelor and doctoral degrees in astronomy from Harvard University, and has held appointments at Harvard, the State University of New York at Stony Brook, and the University of Massachusetts at Amherst, where he served as chair of the Five-College Astronomy Department for nearly fourteen years. For the past twenty years, Stephen's research has been focused on studies of forming stars and planetary systems.

Since 1978, Stephen has photographed extensively in the American Southwest. His work has appeared in more than thirty exhibitions throughout the United States and in a number of collections, including the Center for Creative Photography at the University of Arizona and the Mead Museum in Amherst, Massachusetts. His interpretations of landscapes in the Four Corners region accompany Joy Harjo's poems in *Secrets from the Center of the World* (1989), part of the Sun Tracks series published by the University of Arizona Press. Stephen's photographs also accompany the essays of Carl and Jane Bock in *Sonoita Plain: Views from a Southwestern Grassland* (University of Arizona Press, 2005).